DOLLARS BILLETS DOUX

by Zabo

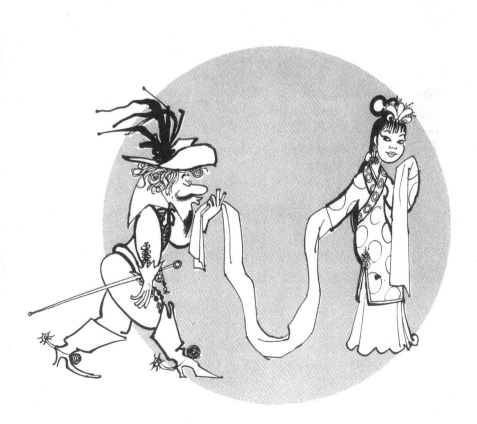

Hong Kong Sweet and Sour
ISBN 978-988-13765-9-6

Published by Blacksmith Books
Unit 26, 19/F, Block B, Wah Lok Industrial Centre,
37-41 Shan Mei Street, Fo Tan, Hong Kong
Tel: (+852) 2877 7899
www.blacksmithbooks.com

The author wishes to mention that some of the cartoons printed
in this book first appeared in the Sunday edition of the
South China Morning Post.

« Hong Kong
is a money splendoured thing »

honni soit qui mal y dépense

Introduction

I first saw a copy of Daniel Zabo's *Hong Kong Sweet and Sour* in a second-hand bookshop in Hong Kong. What I found most striking was how many of the artist's 1960s cultural observations still rang true 50 years later. It's reassuring to know that some things do stay the same. People in Hong Kong still crowd into dim sum restaurants at weekends, the pavements and buses are as packed as they ever were, bamboo scaffolding clings to tall buildings even now, the floating restaurants successfully stay above water – and Chinese and Westerners still fail to understand each other, to timeless comic effect.

The 1960s were a decade of change and opportunity for Hong Kong. Refugees had poured into the then-colony to staff the factories that produced clothes and toys for the world. Drastic water shortages meant that many people had water for only four hours every four days. American ships were a common sight in the harbour, bringing US servicemen on R&R trips from Vietnam. And in China, the mystifying Cultural Revolution was raging on, drawing curious visitors to lookout points on the closed border.

At the same time, air travel was becoming accessible to people in the West for the first time, and Hong Kong became a stopover on intercontinental flights. The city became a window on China and a tourist destination in its own right. *Love is a Many-Splendoured Thing* and *The World of Suzie Wong* fixed an image of Hong Kong in the Western mind which may not have been accurate but which brought the tourist dollars rolling in.

I mentioned this fantastic book to my friend David, a publisher in France, and he told me that he knew Zabo, who was alive and well. Zabo agreed to bring *Hong Kong Sweet and Sour* back to life, five decades after it first appeared in print. I hope you enjoy this new edition – and find echoes in your own experience of Hong Kong!

Pete Spurrier

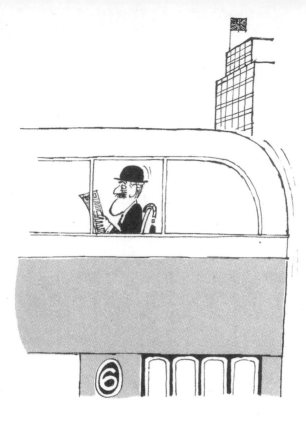

LONDON?

NO...

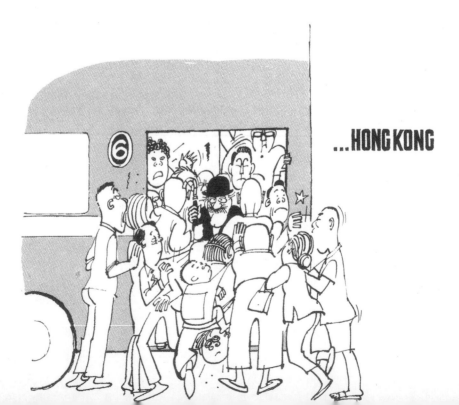

...HONG KONG

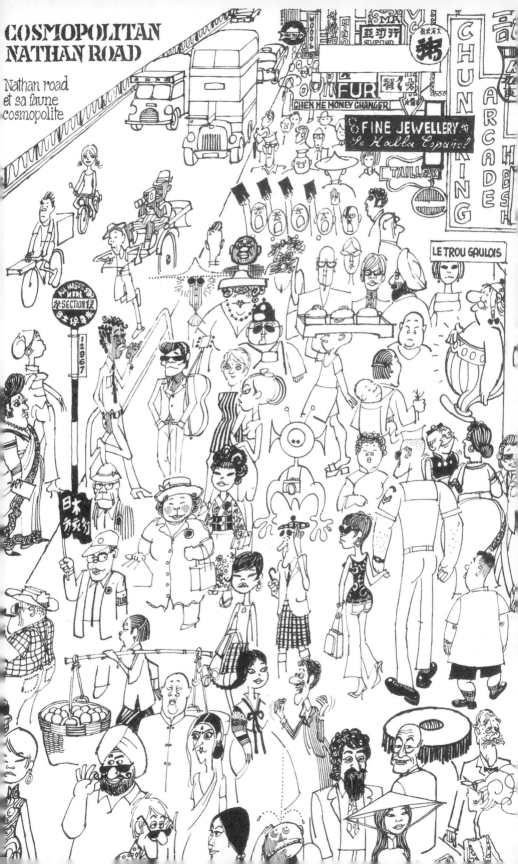

COSMOPOLITAN NATHAN ROAD

Nathan road et sa faune cosmopolite

Discovering the "cheong sam"
Decouverte du cheong sam (robe chinoise)

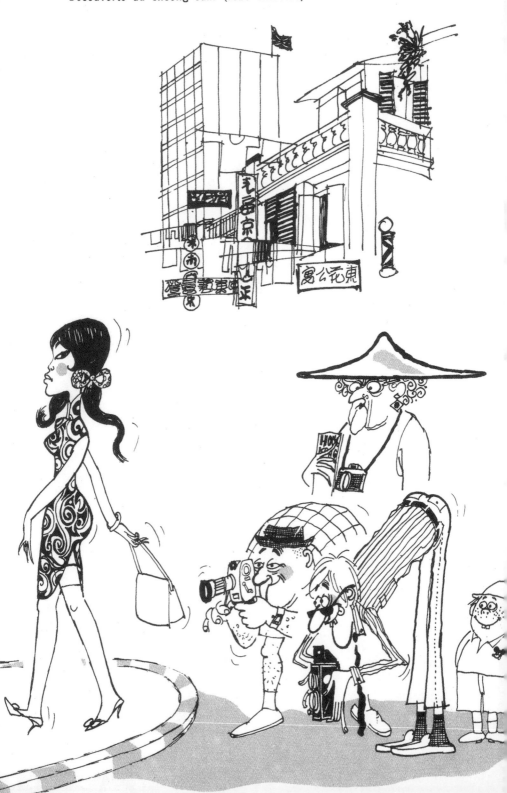

DIFFERENT POINTS OF VIEW!
Selon les continents, la morale se situe au niveau du soutien-gorge, ou de la jarretelle.

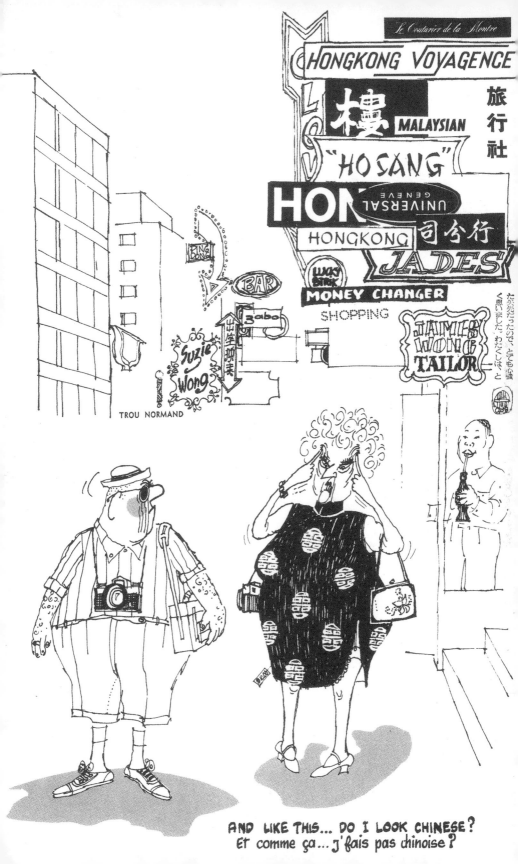

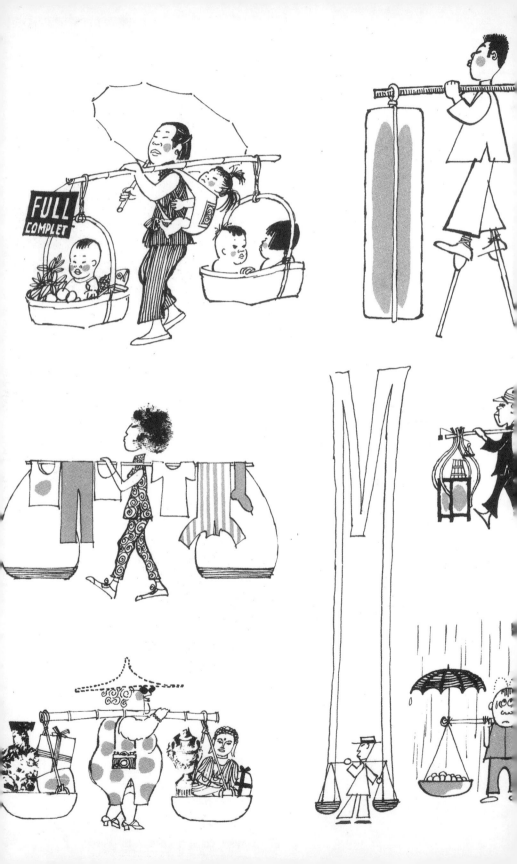

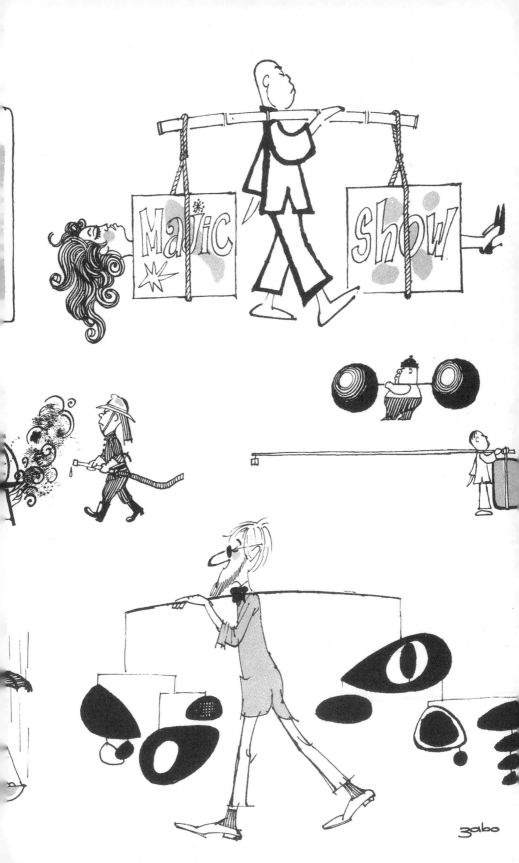

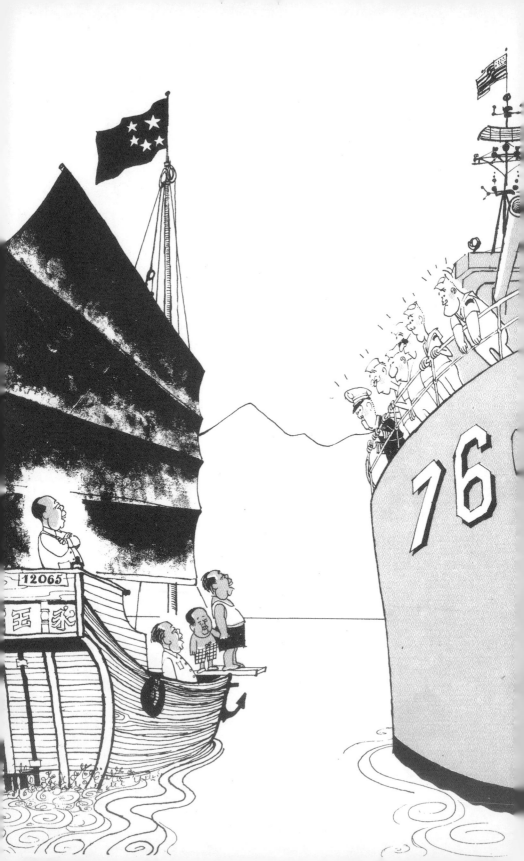

AN HING IVORY FACTORY
WHOLE SALE AND RETAIL

COMPREHENSIVE
CERTIFICATE OF ORIGIN
FOR IVORY AVAILABLE

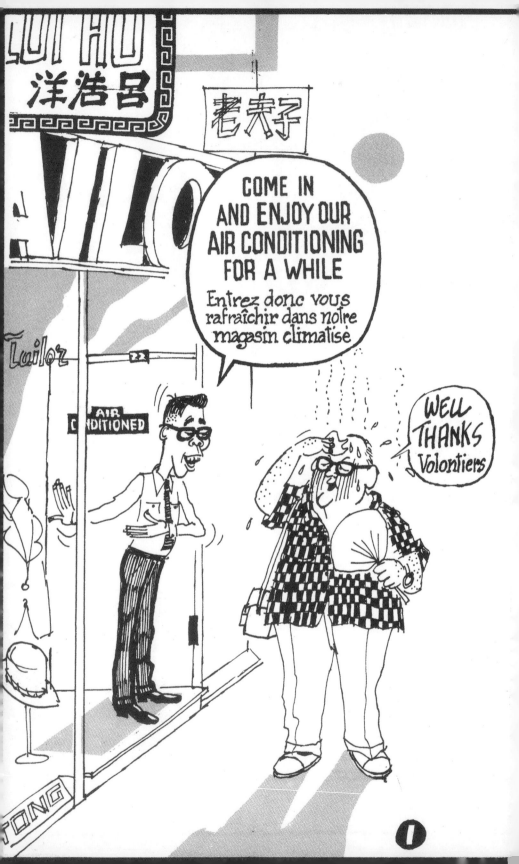

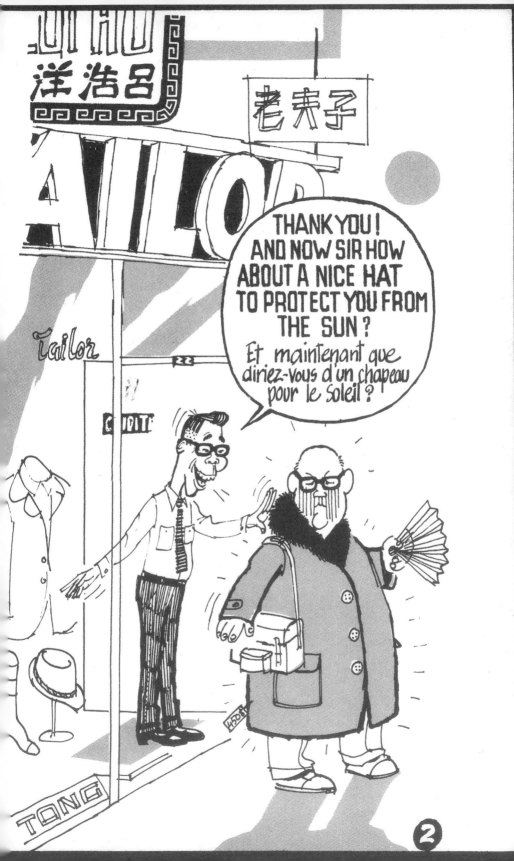

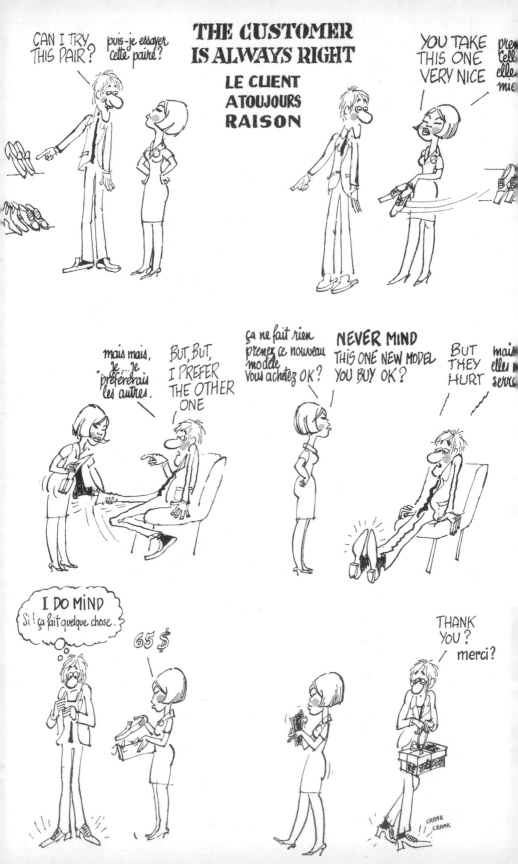

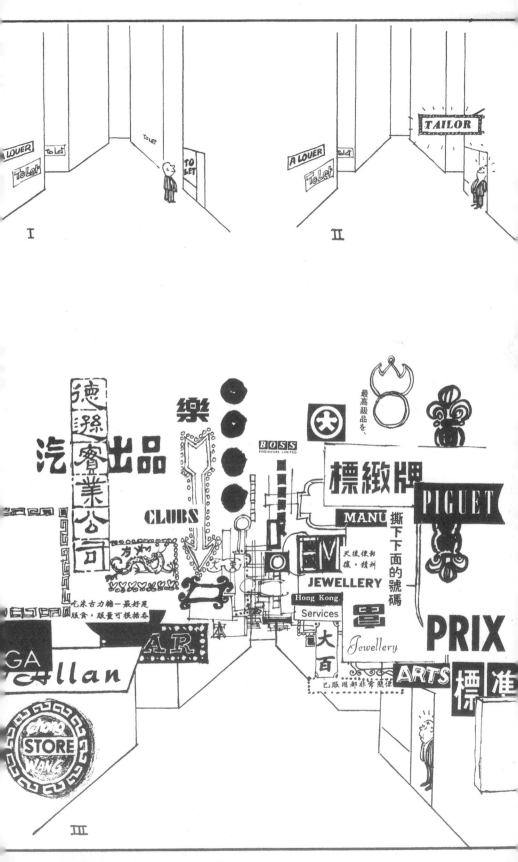

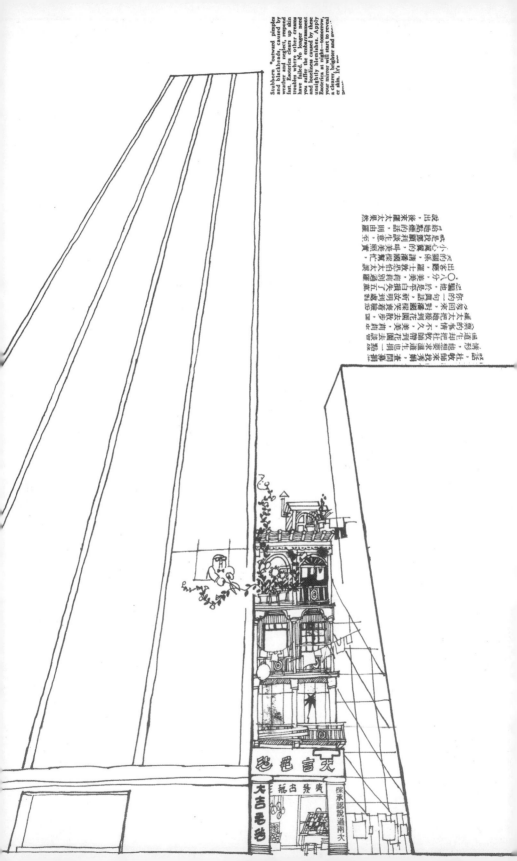

Stubborn "outward" pimples and blackheads, caused by weather and neglect, respond fast. Esoterica clears skin trouble where other creams have failed. No longer need you suffer the embarrassment and loneliness caused by these unsightly blemishes. Apply Esoterica at night—tomorrow your mirror will start to reveal a clearer, brighter and sm... er skin. It's wo...

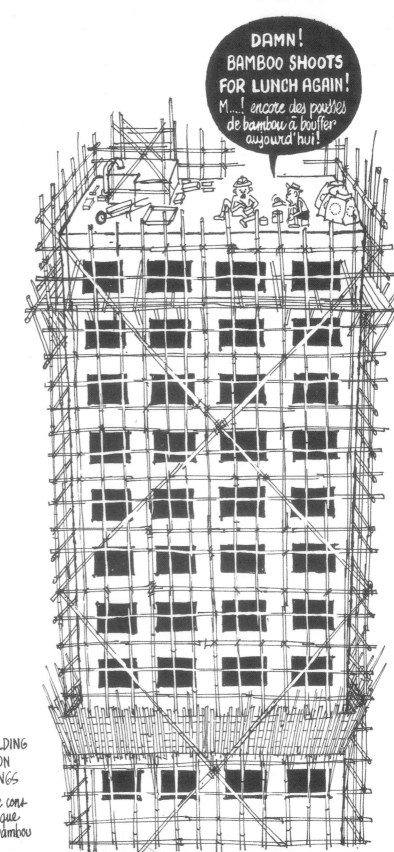

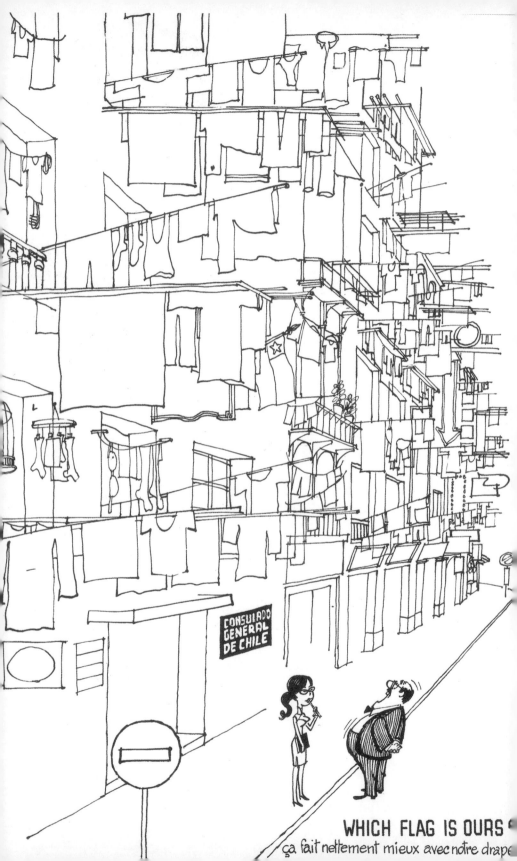

CONSULADO GENERAL DE CHILE

WHICH FLAG IS OURS
ça fait nettement mieux avec notre drape

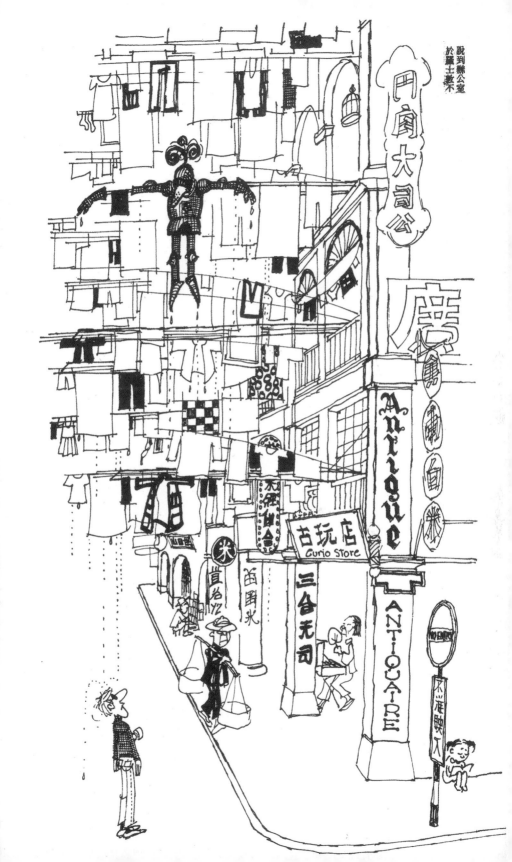

ADVICE TO A KWAI LO FOR THE MOON FESTIVAL

Conseils à un KWAI LO (étranger) Pour le festival de la lune

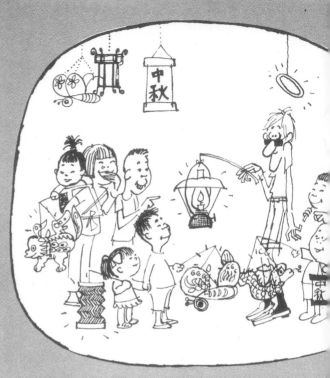

BUY A LANTERN...
achetez une lanterne...

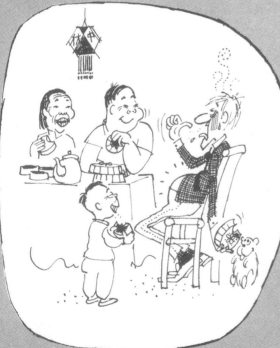

EAT A MOON CAKE...
goûtez à un gâteau de lune ...

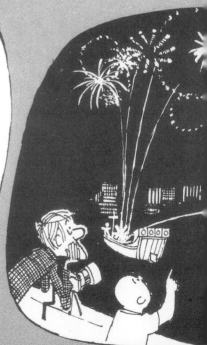

WATCH FIRE WORKS BY COU
comme la U.S. navy assistez a

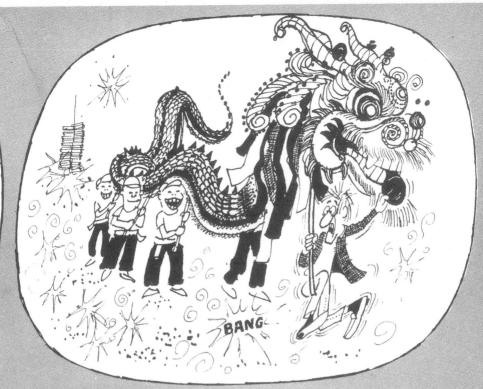

ENJOY A DRAGON DANCE...
dansez avec un gentil dragon

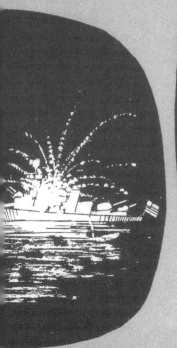

OF "UNCLE MAO"...
artifice de "Tonton MAO"...

AND LOOK AT THE MOON
et contemplez la lune.

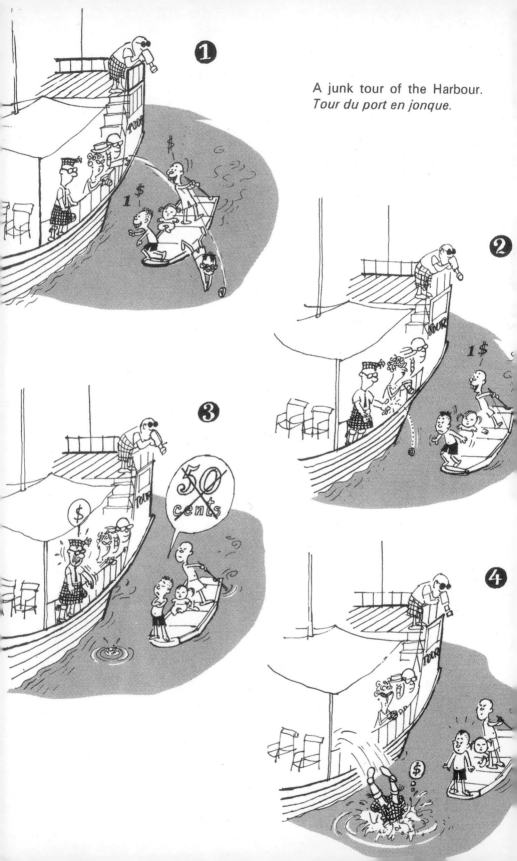

A junk tour of the Harbour.
Tour du port en jonque.

EVERYDAY 120.000 PEOPLE HAVE A PLEASANT CROSSING ON "THE STAR FERRY"

120.000 personnes se plaisent à "prendre chaque jour le star ferry" (bac)

IS THE FIRST CLASS TOO CHEAP?
la 1ère classe est-elle encore trop bon marché

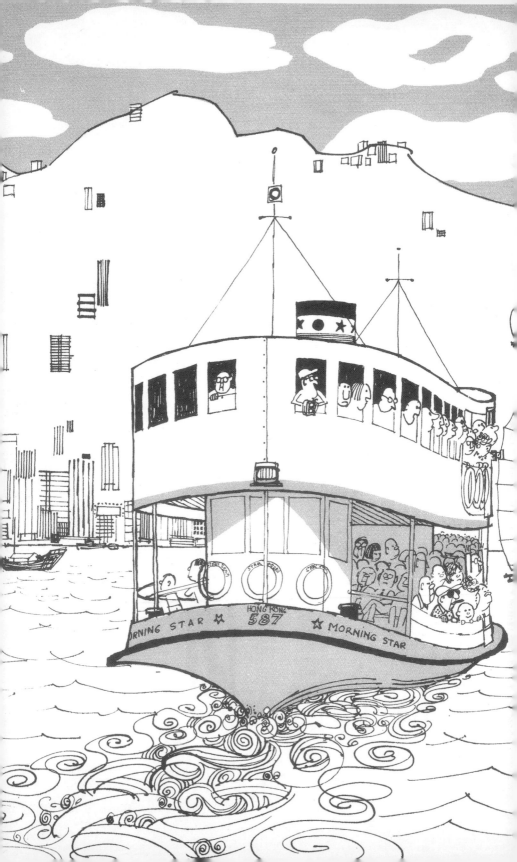

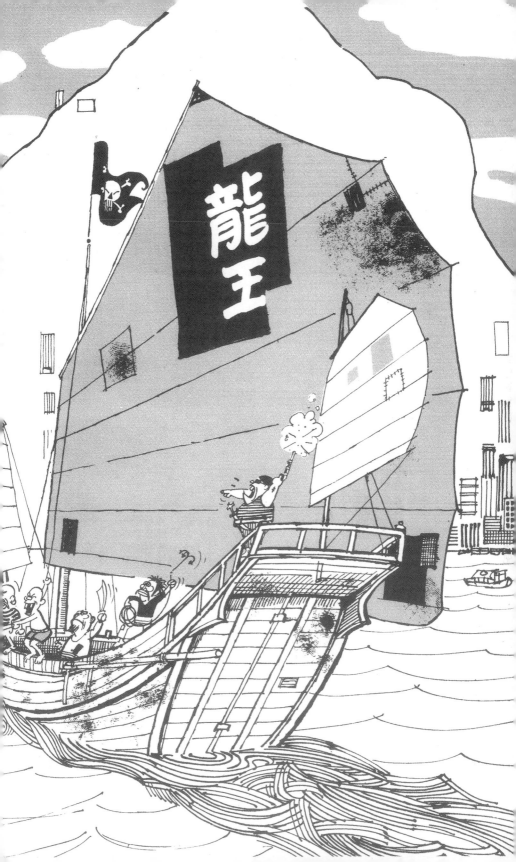

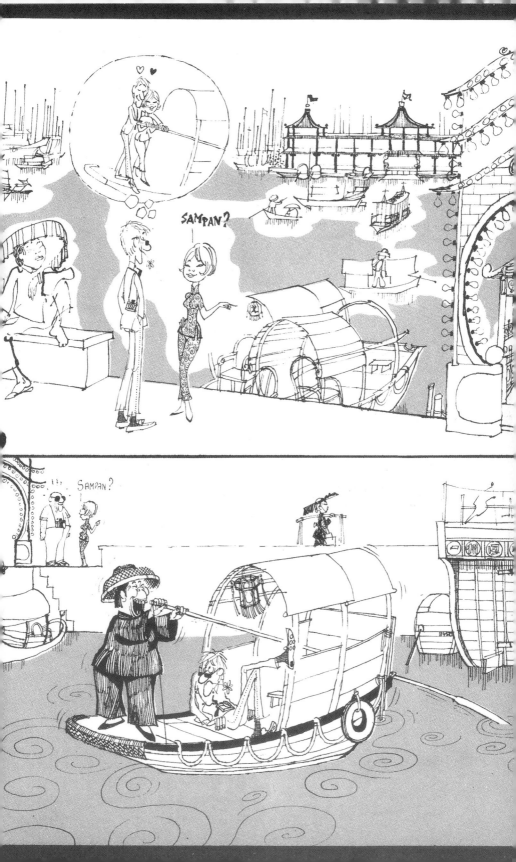

Floating restaurant, Aberdeen.
restaurant flottant, à Aberdeen.

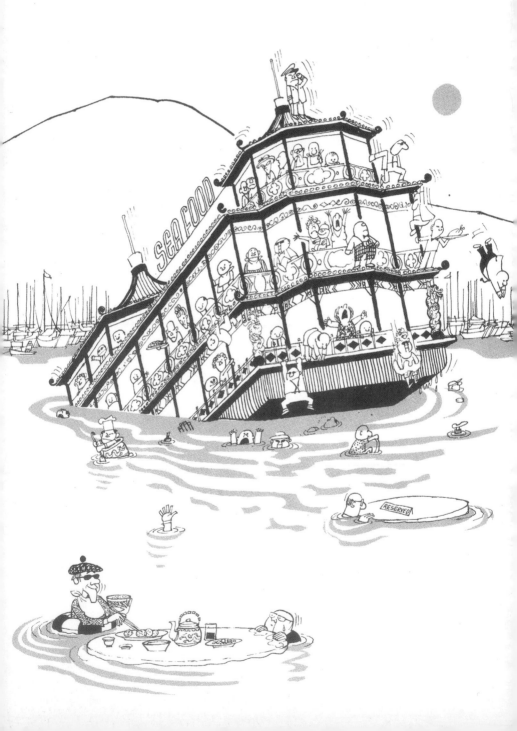

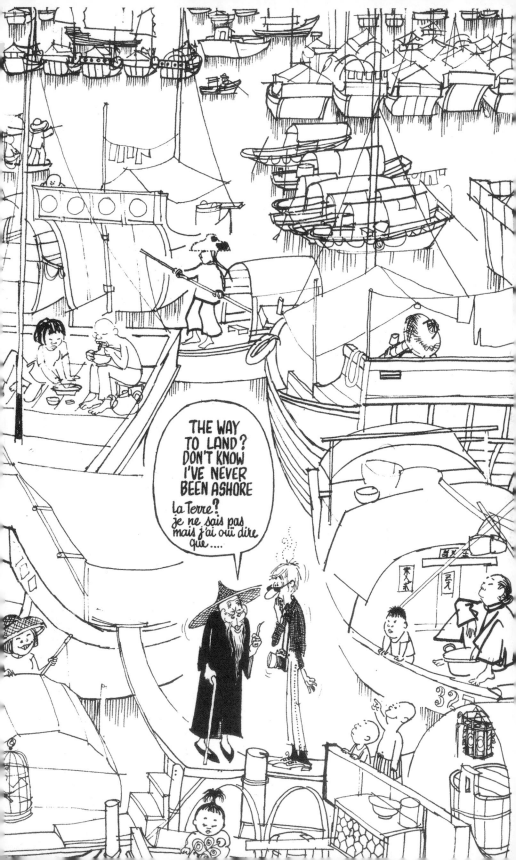

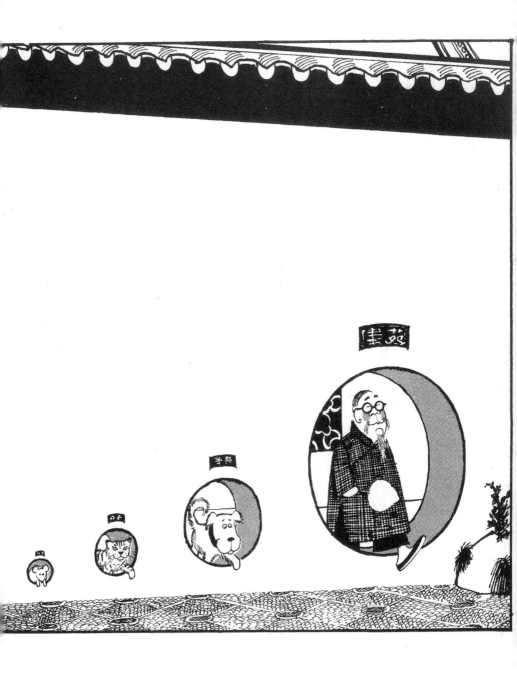

Tin Hau Festival at Yuen-long is in homage to the goddess of heaven in which dragon and lion dances are performed.

le Festival de Tin Hau qui a lieu à Yuen-long, célèbre l'anniversaire de la naissance de Tin Hau, déesse du ciel, qui protège les pêcheurs. Nombreuses danses de dragons et de lions.

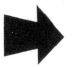

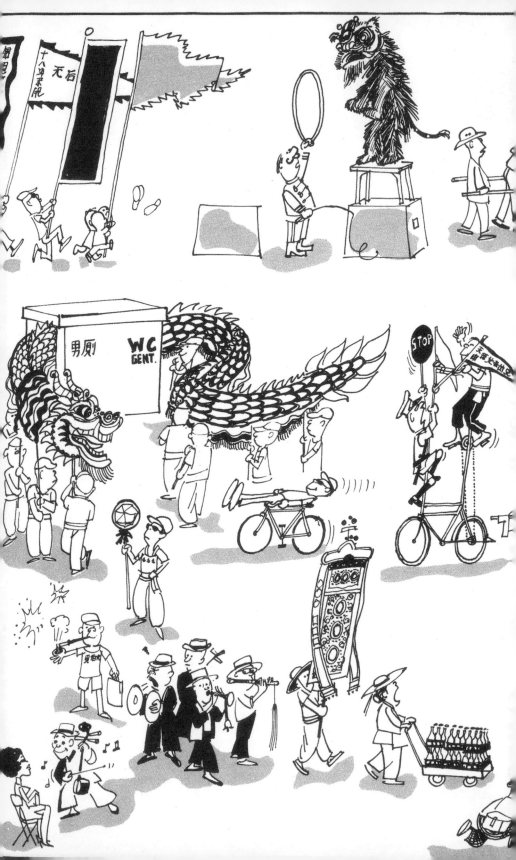

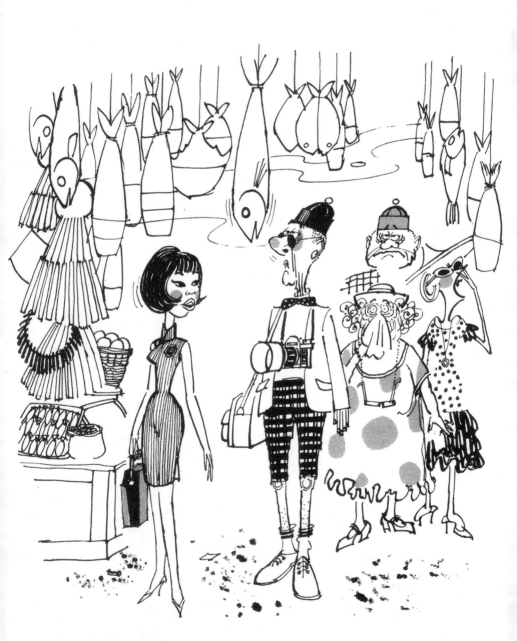

HONG KONG MEANS "FRAGRANT HARBOUR"
En chinois HONG KONG signifie "PORT PARFUMÉ"

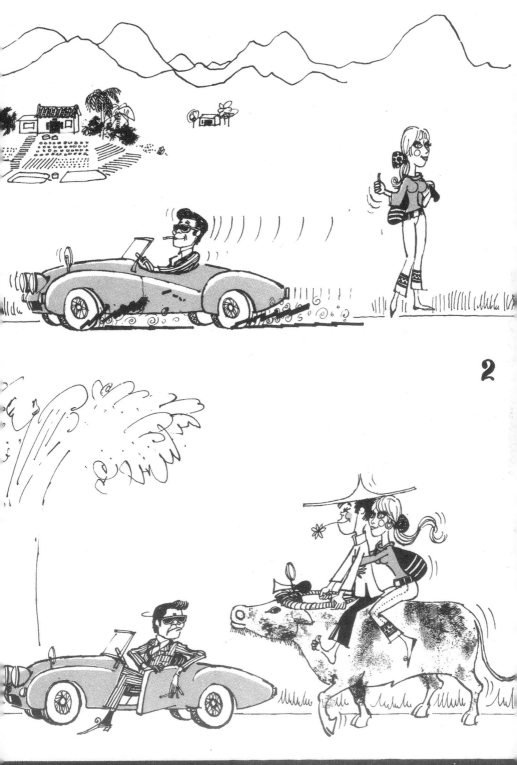

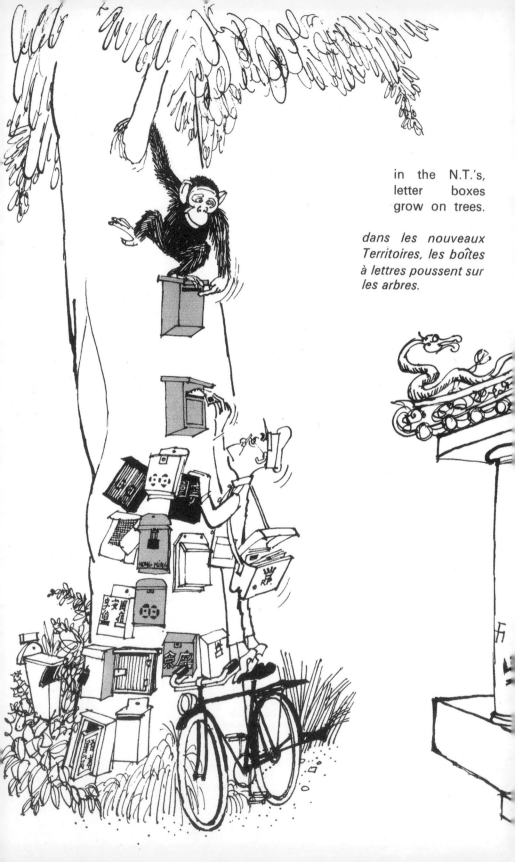

in the N.T.'s, letter boxes grow on trees.

dans les nouveaux Territoires, les boîtes à lettres poussent sur les arbres.

The Swastika was Buddhist before it was German.
La croix gammée était Bouddhique avant d'être nazi.

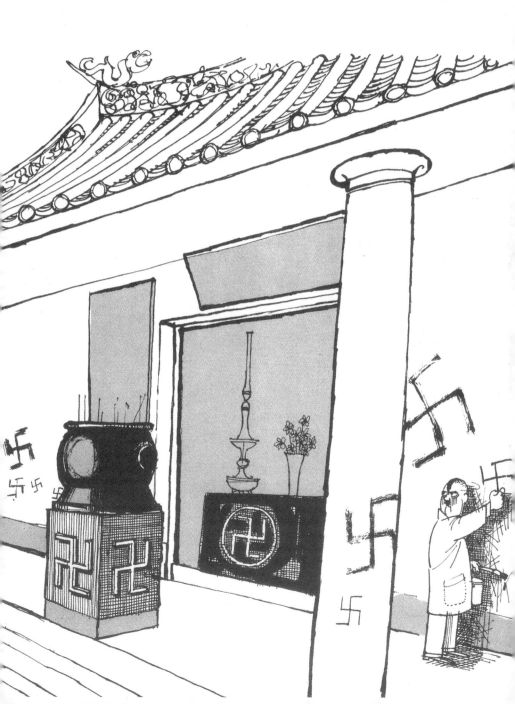

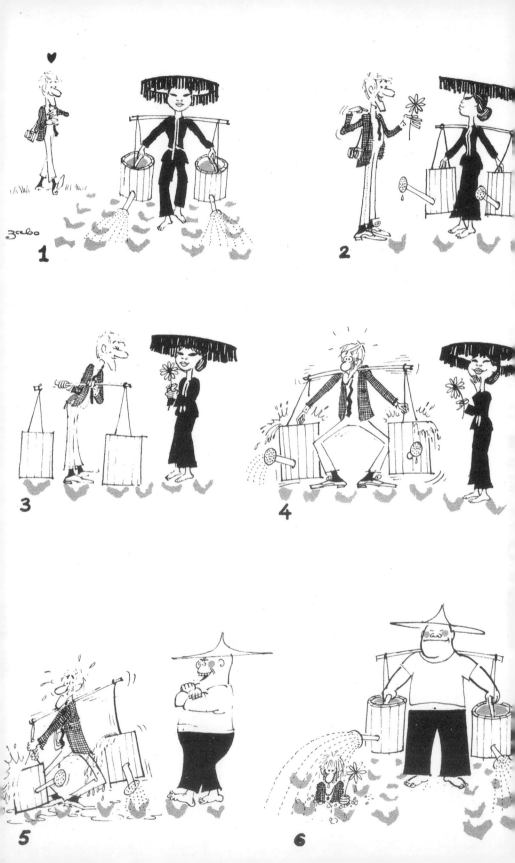

Temple of Ten Thousand Buddhas at Sha Tin.
le temple des dix mille bouddhas à Sha-tin.

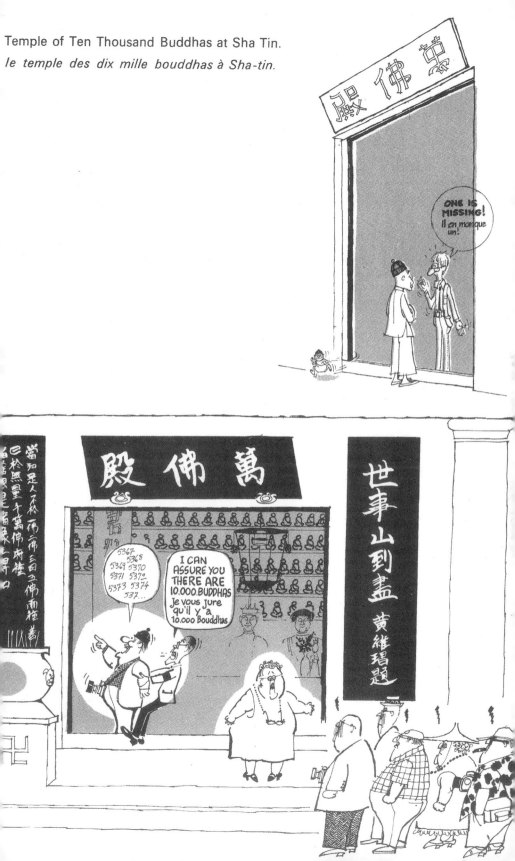

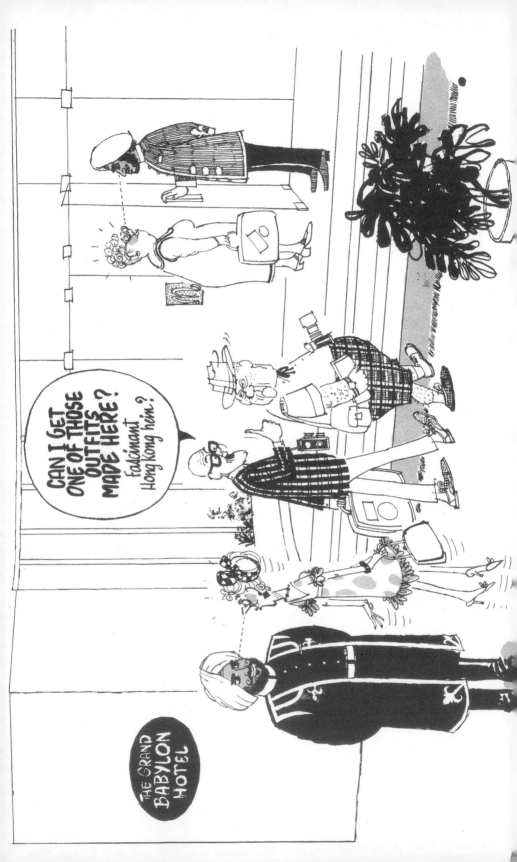

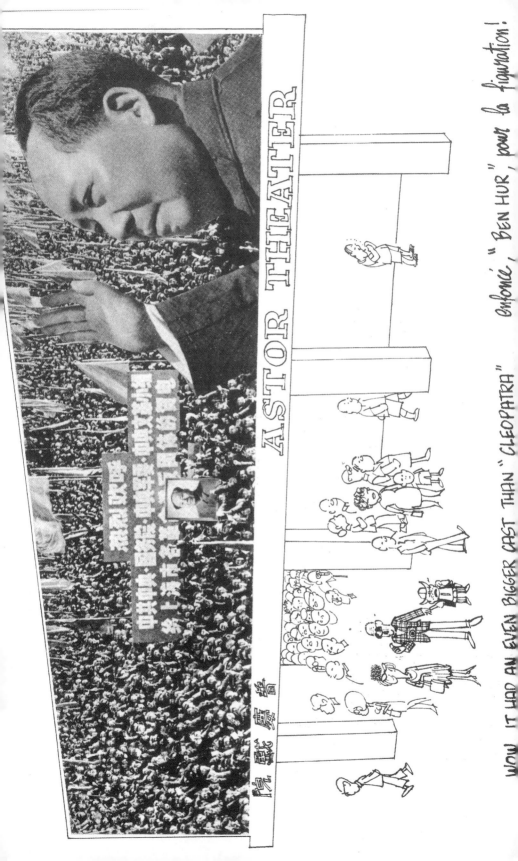

ASTOR THEATER

Enfoncé, "BEN HUR", pour la figuration!

WOW! IT HAD AN EVEN BIGGER CAST THAN "CLEOPATRA"

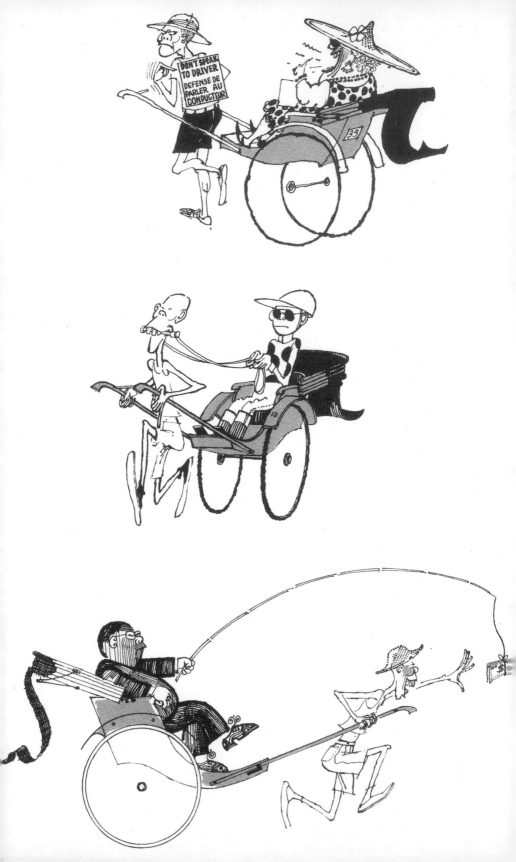

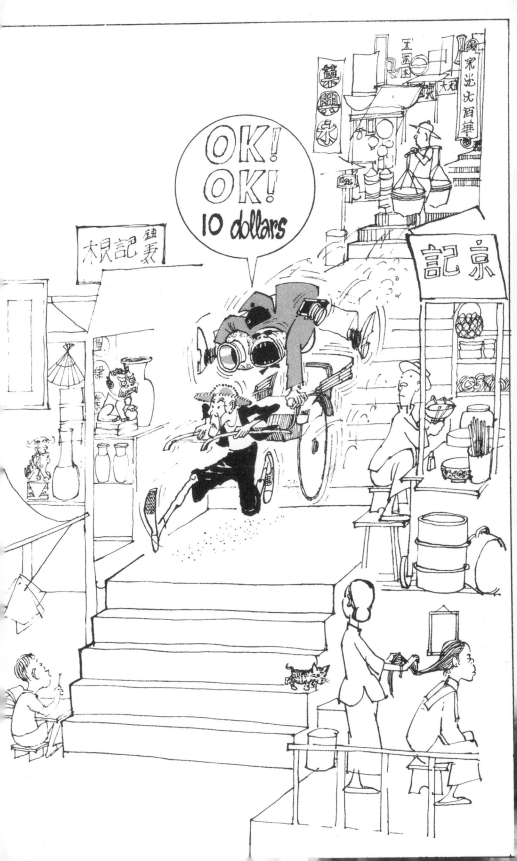

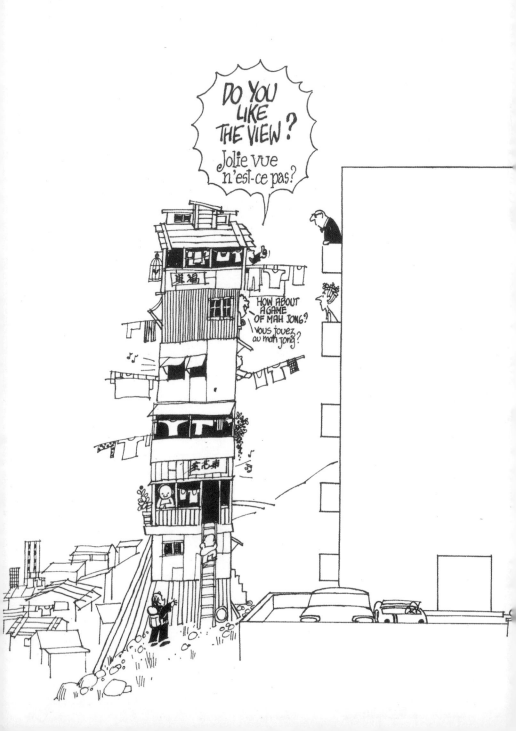

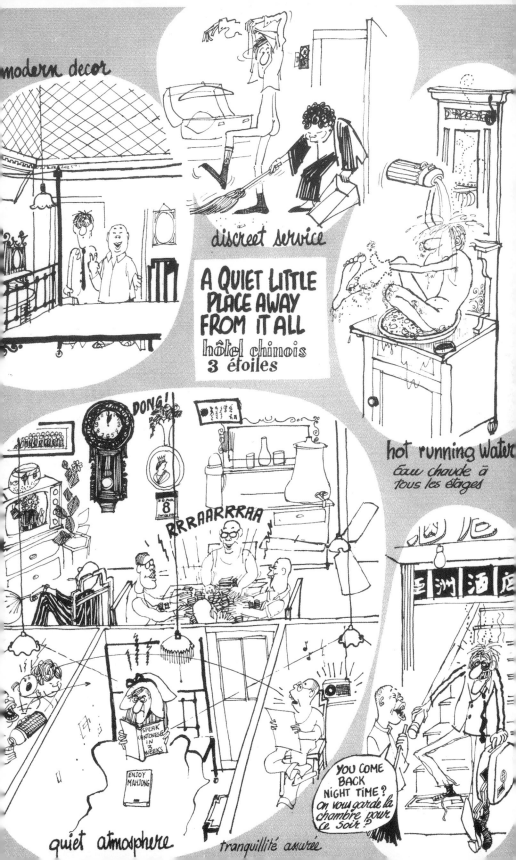

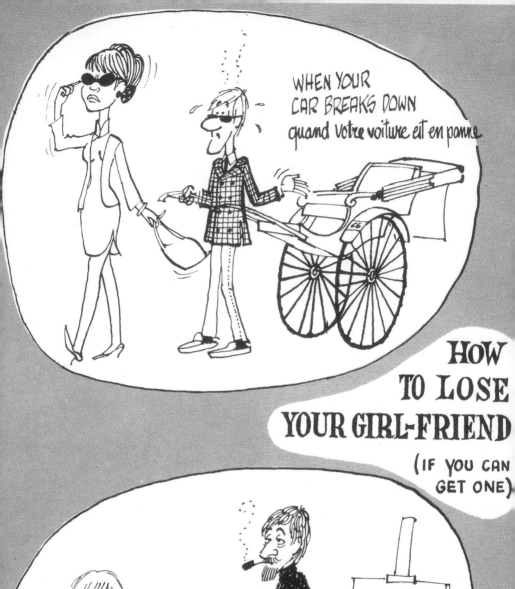

WHEN YOUR
CAR BREAKS DOWN
quand Votre voiture est en panne

HOW
TO LOSE
YOUR GIRL-FRIEND
(IF YOU CAN
GET ONE)

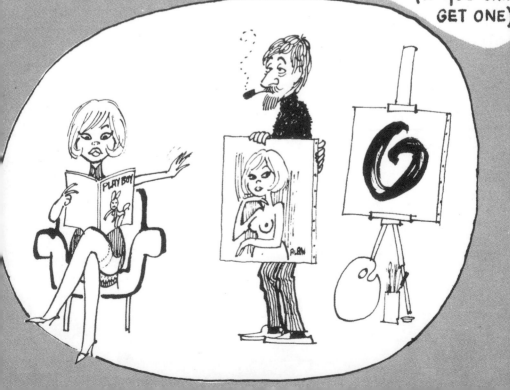

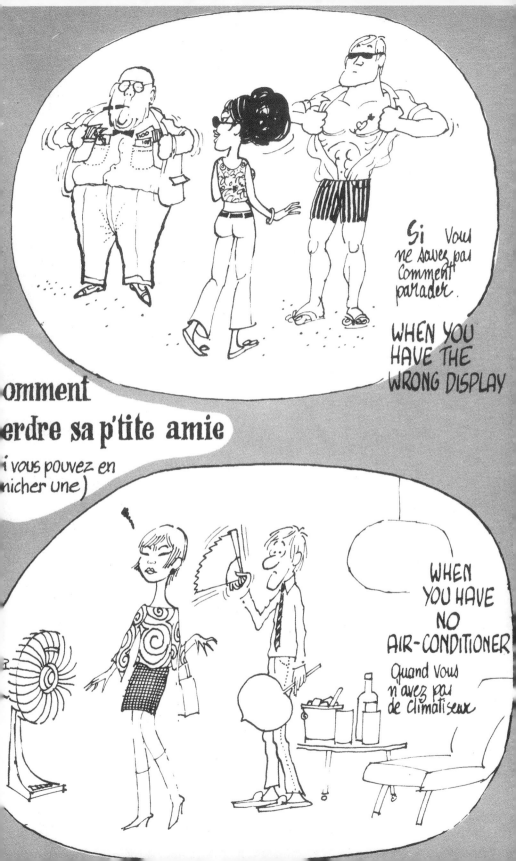

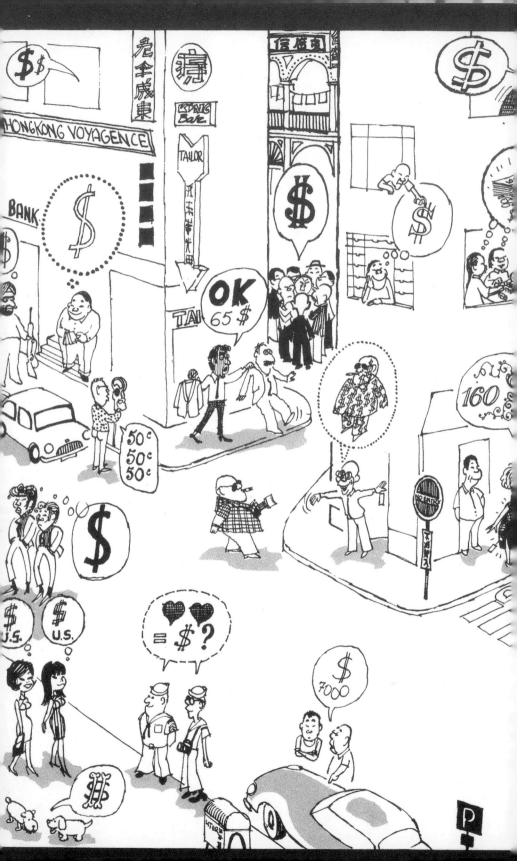

PSYCHIATRIST 心理治療

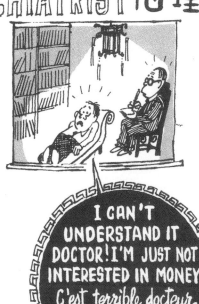

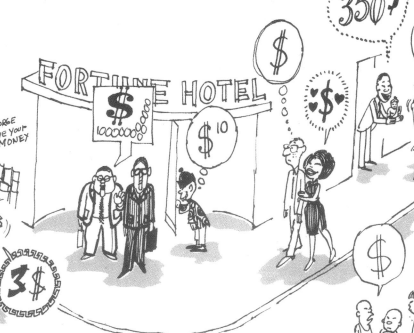

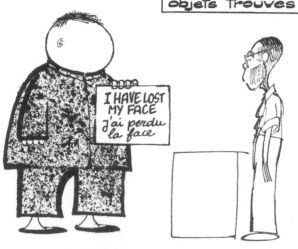

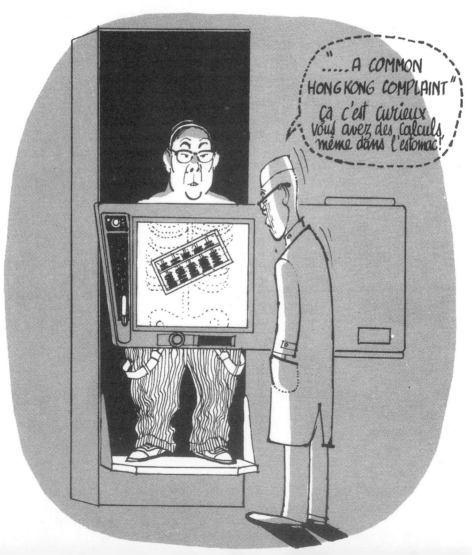

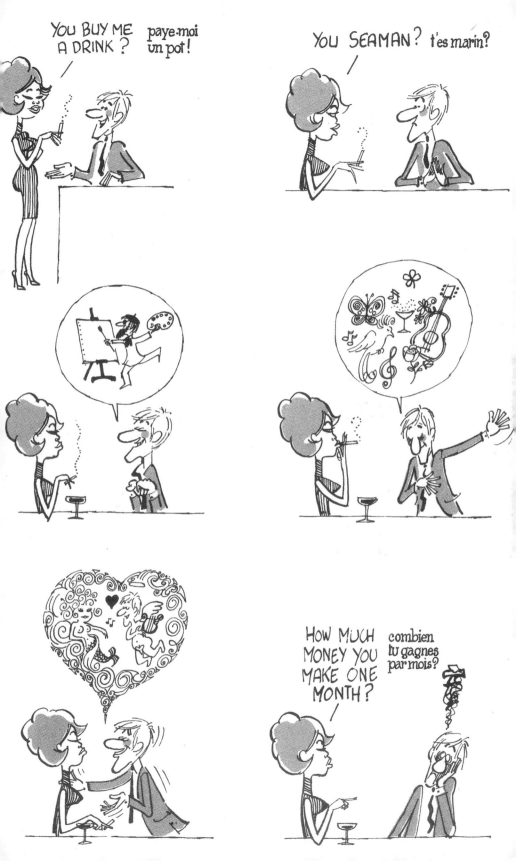

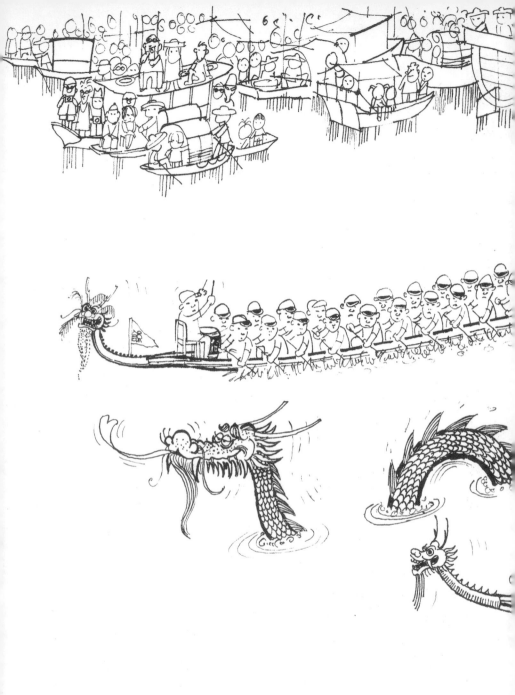

zabo

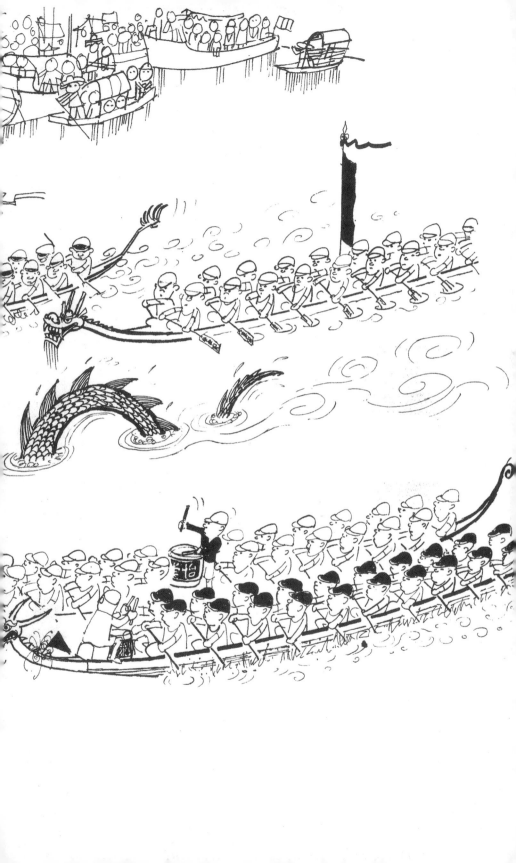

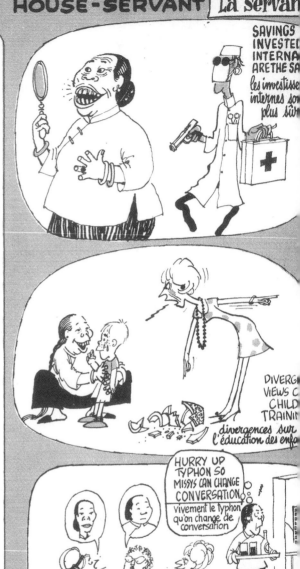
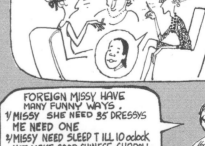

Every morning, one hour after sunrise, the Chinese system of exercises Tai Chi Chuan, is practiced. It is claimed to cure all spiritual and physical defects, and resembles a slow motion ballet.

Une heure après le lever du soleil, comme dans un ballet filmé au ralenti, se pratique la gymnastique chinoise Tai Tchi Tchuan, remède miracle pour votre ligne et vos maladies.... (obésité, rachitisme, constipation, cocuage, etc.:)

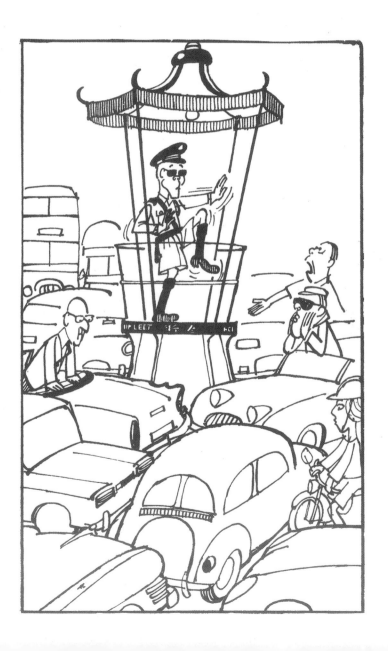

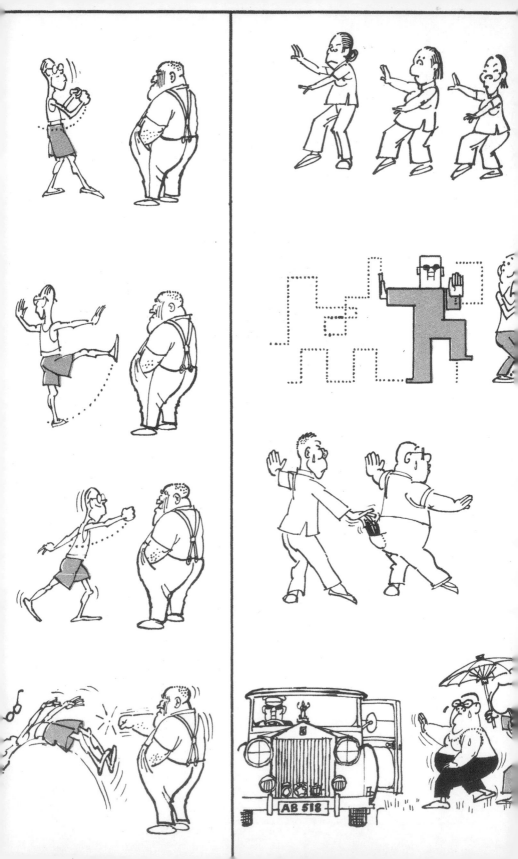

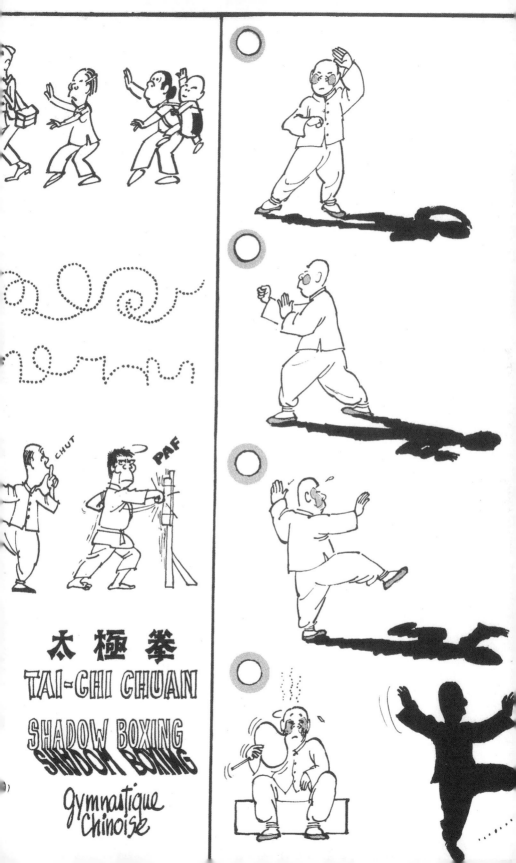

It is believed by all fishermen of Cheung Chau that whoever gets the buns will have luck and good fortune for the whole year. At 11 p.m. the chief priest gives the signal to snatch the buns. In a few minutes the three big towers are stripped completely.

Au Festival de Cheung Chau, 3 immenses pièces montées sont offertes aux pêcheurs de l'endroit, qui sont persuadés que quiconque mange de leurs gâteaux est sûr de jouir de la santé et la forturne toute l'année. Au coup de gong, ils se précipitent et les tours sont dépouillées en un instant.

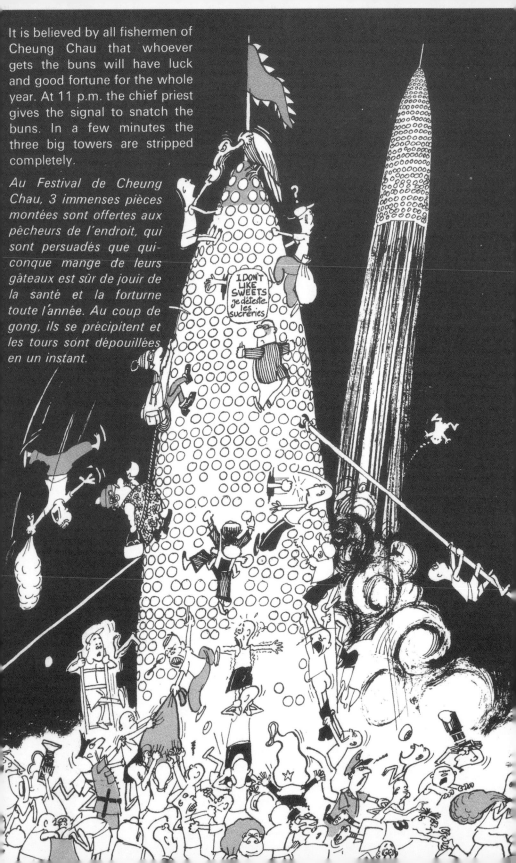

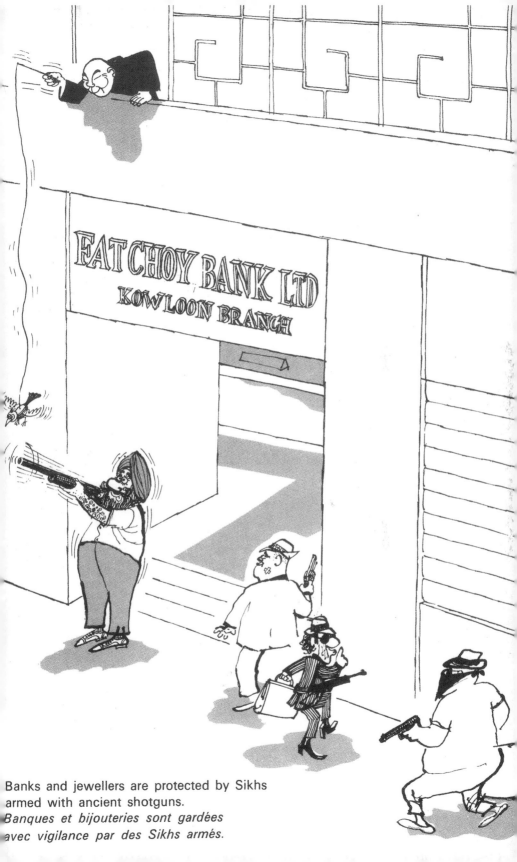

Banks and jewellers are protected by Sikhs
armed with ancient shotguns.
*Banques et bijouteries sont gardées
avec vigilance par des Sikhs armés.*

The revolving table.
la table tournante,
(ou l'art de saisir au vol)

en sûr
e le canard
Pékin
ent de chine!

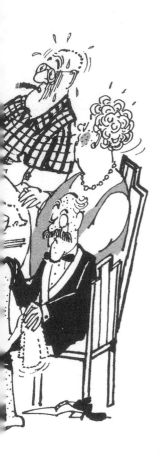

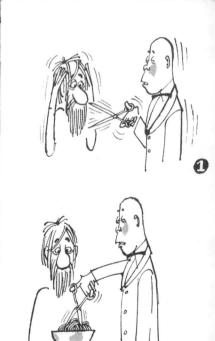

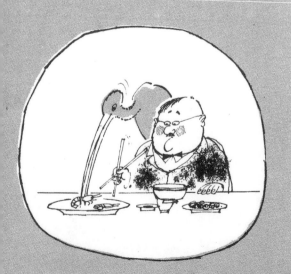

The little restaurant with the big sign. "the chopsticks are no trouble......
but the seats......"
Dans les Tai Pai Thon (petits restaurants aux grandes enseignes) manier les
baguettes passe......mais s'asseoir! c'est autre chose.

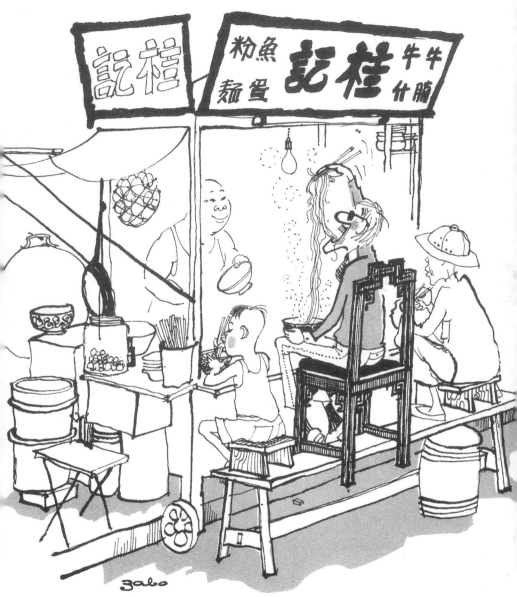

Yam Tcha (Drink tea) For gourmets in a hurry: Sit down and
order one of the many delicious dishes from the charming young
waitresses, whose gracious smiles could bear striking resemblance
to those of New York taxi drivers caught in a traffic jam.

Pour fins gourmets pressés, le "yam tcha" (boire du thé)·asseyez-
vous, et commandez au passage mille choses délicieuses auprès
de charmantes jeunes filles, dont le gracieux sourire rappelle de
façon frappante celui d'un chauffeur parisien pris dans un
embouteillage.

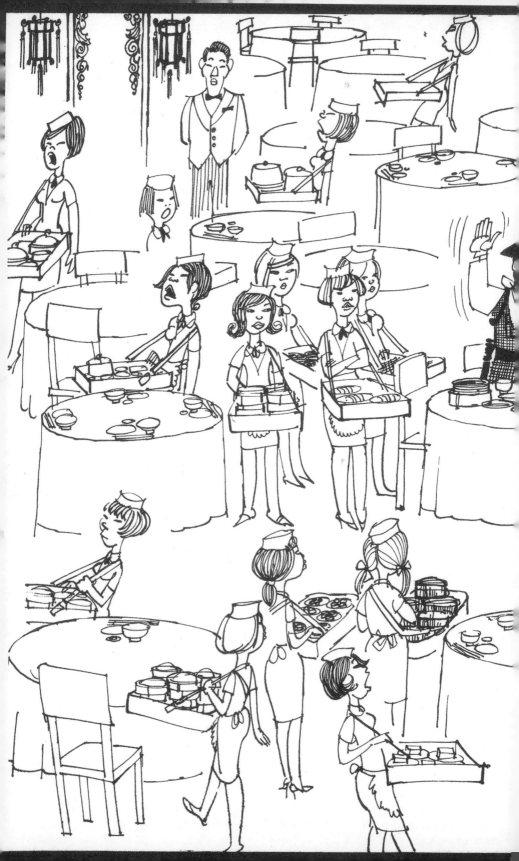

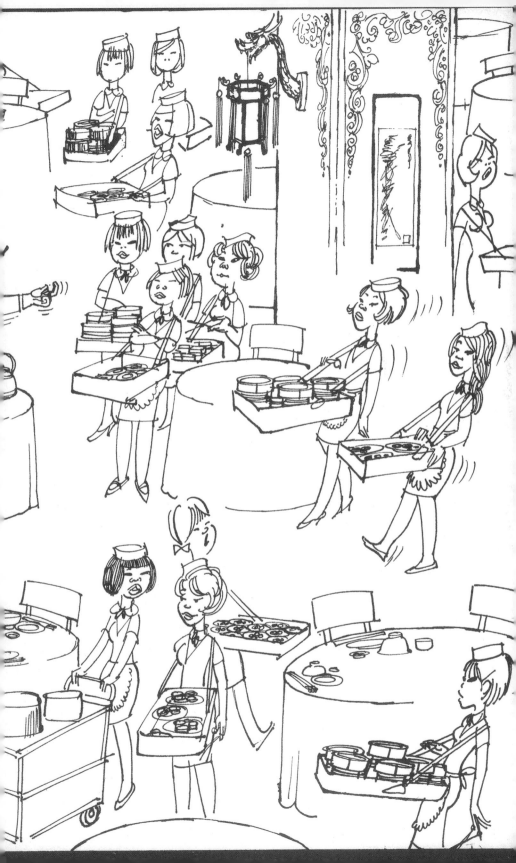

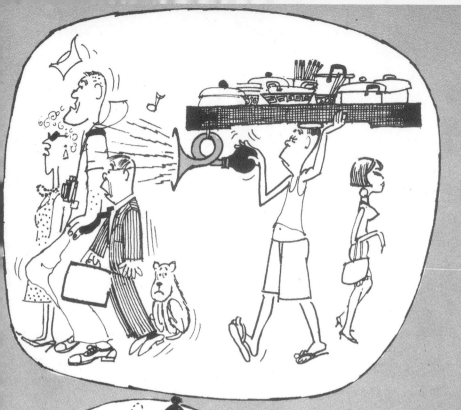

AT ANY TIME OF THE DAY YOU CAN ORDER A MEAL FROM THE CORNER RESTAURANT

à toute heure du jour, vous pouvez faire venir votre repas du restaurant du coin.

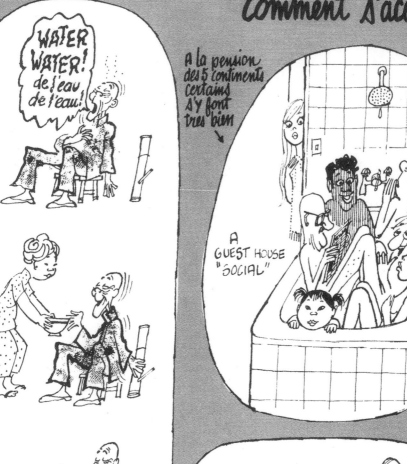

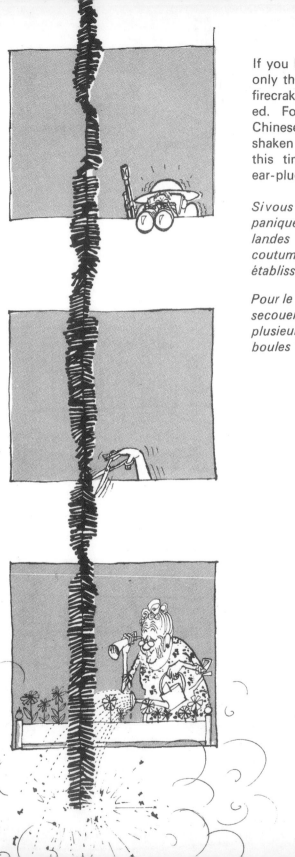

If you hear gunfire, don't panic. It's only the chinese custom of burning firecrakers, when a Business is opened. For several days during the Chinese New Year the town is shaken by the noise of crackers: at this time it is advisable to wear ear-plugs.

Si vous entendez une pétarade, pas de panique ! il s'agit simplement de guirlandes de pétards, qui selon la coutume chinoise inaugurent un établissement.

Pour le nouvel an chinois, les pétards secouent la ville 24 h sur 24 pendant plusieurs jours, n'oubliez pas vos boules "Quies".

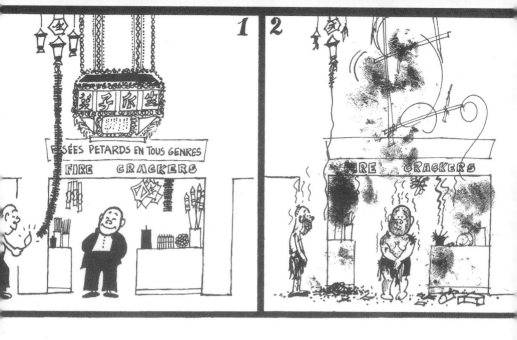

The standing of a firm is judged by how long its fire crackers continue to explode.
Le capital d'un établissement se juge à la durée des pétards.

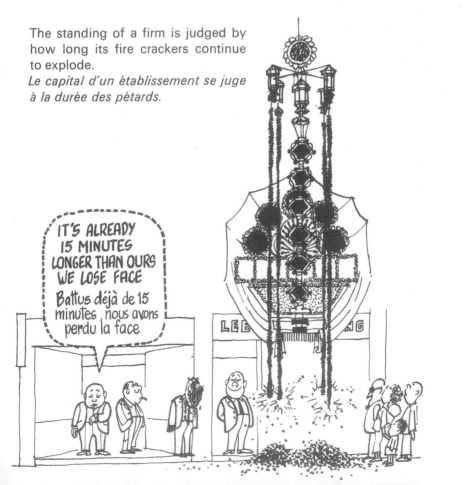

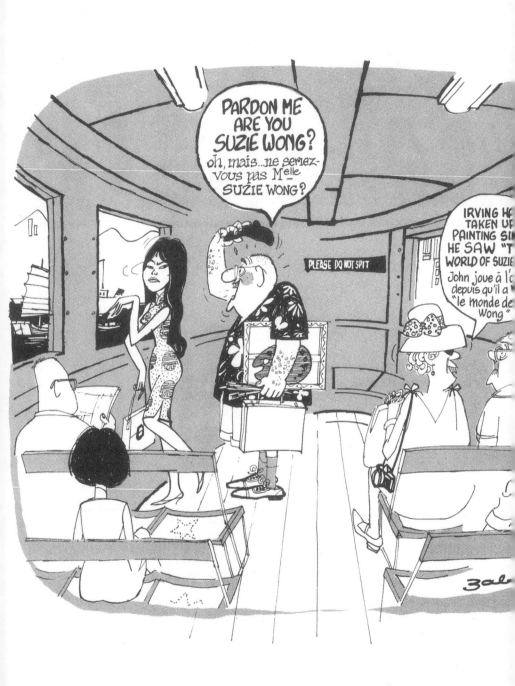

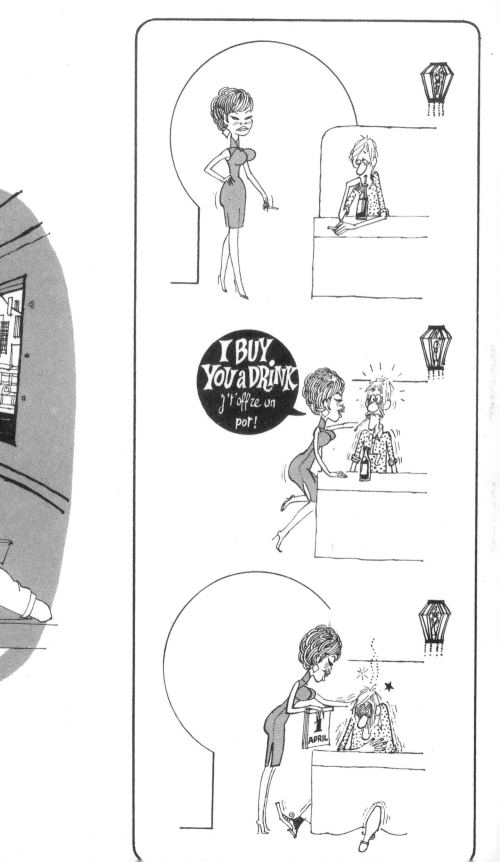

BAMBOO CURTAIN

From the border post of Lok Ma Chau

RIDEAU de BAMBOU

au poste frontière de Lok Ma Ch

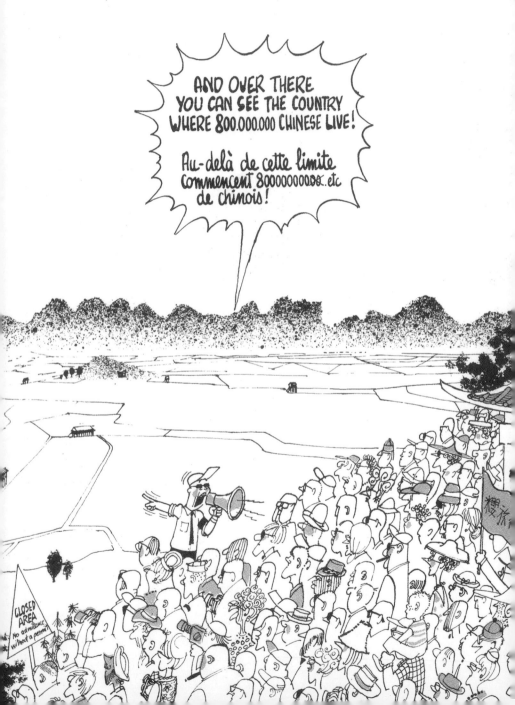

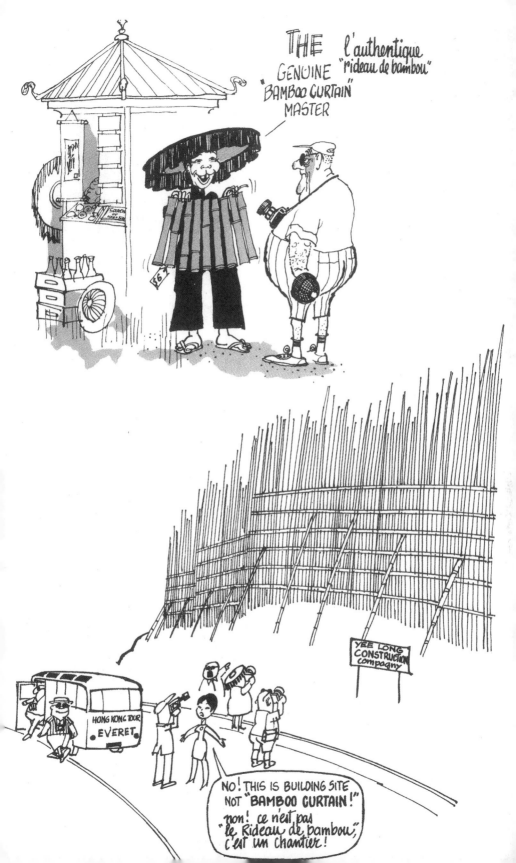

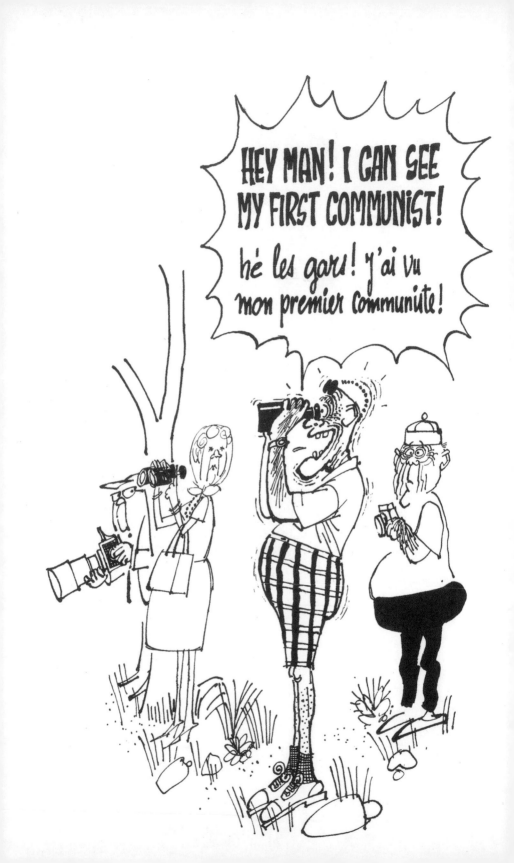

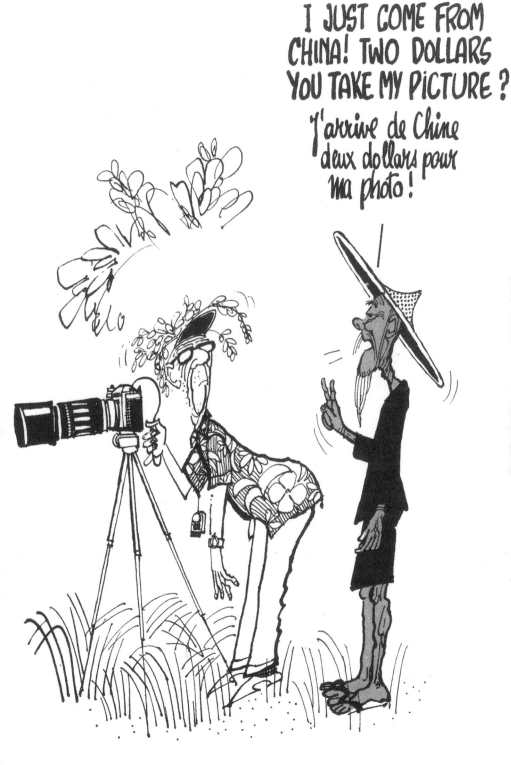

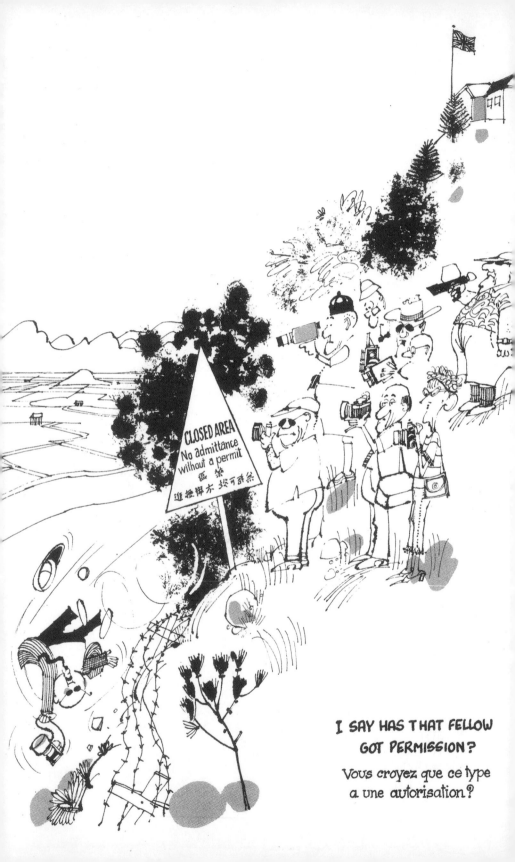

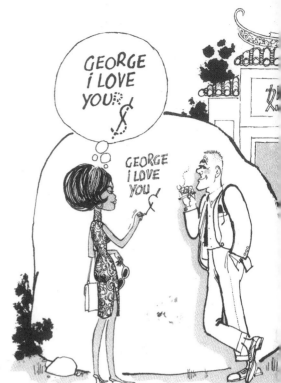

H.K. if all you can afford is flowers, don't bother.

H.K. Si votre compte en banque ne vous permet que des fleurs, abstenez-vous.

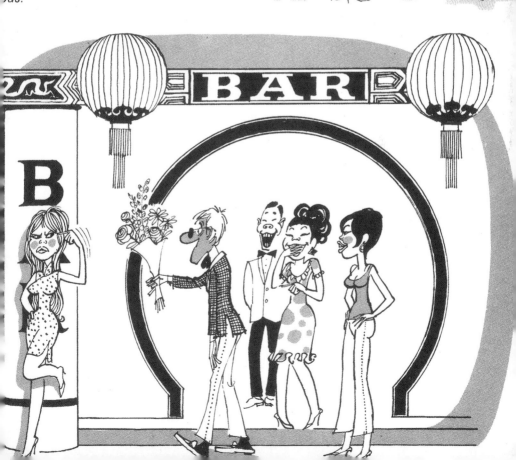

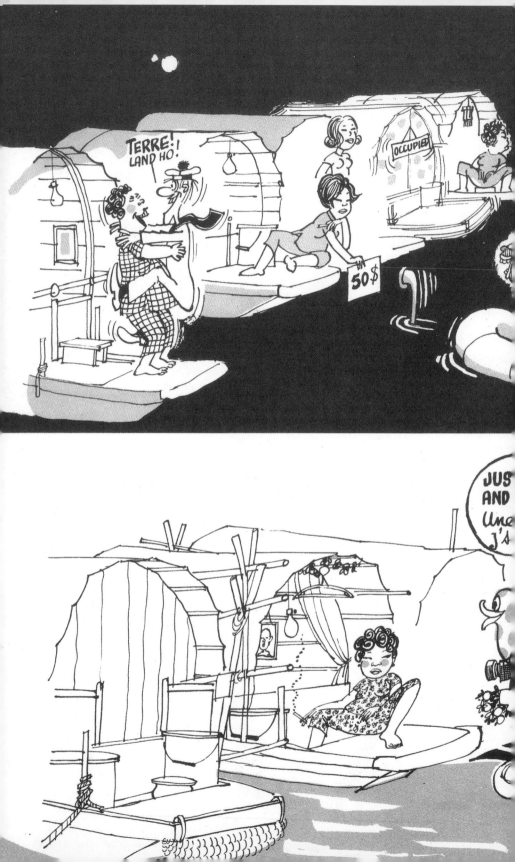

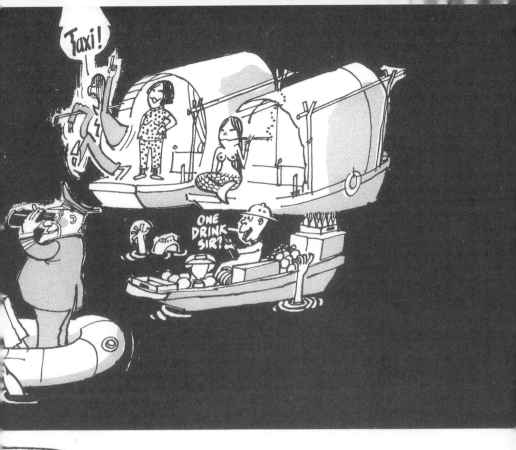

Ecstasy awaits you at the floating paradise of Yau-mati. (Kowloon).

Les filles du ciel vous attendent au paradis flottant de Yau-mati (Kowloon).

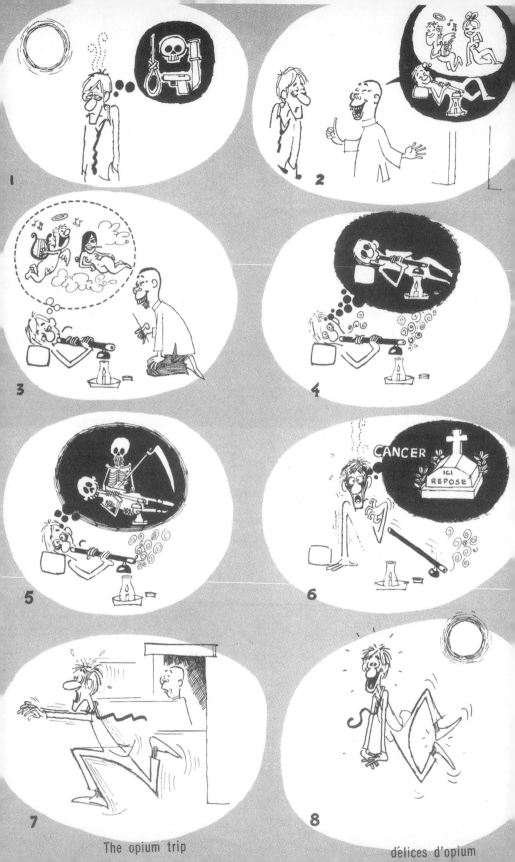

The opium trip

délices d'opium

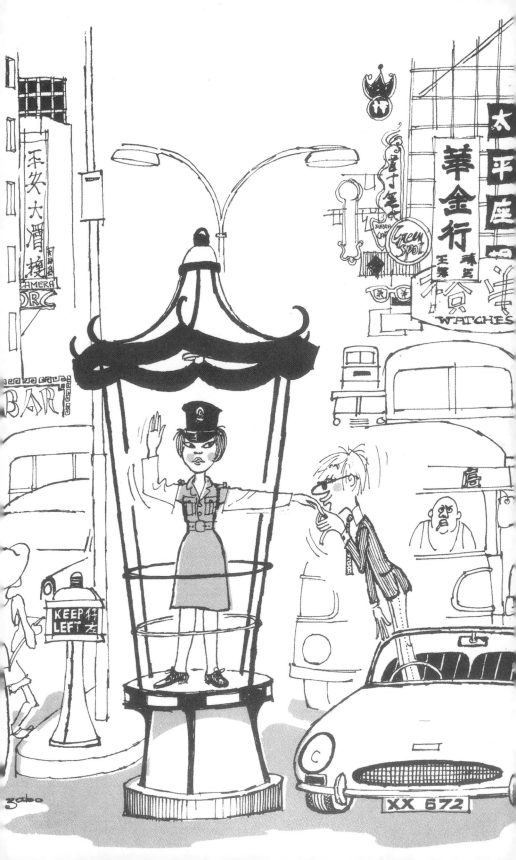

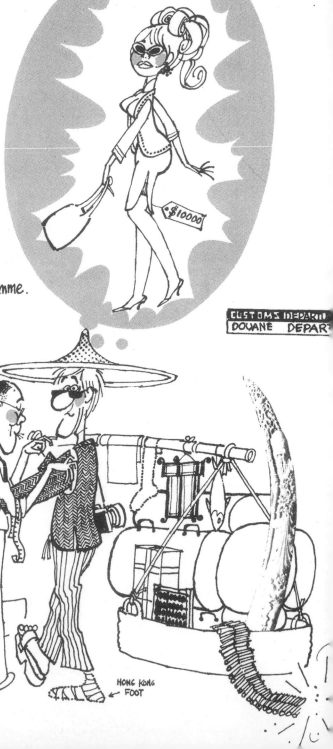